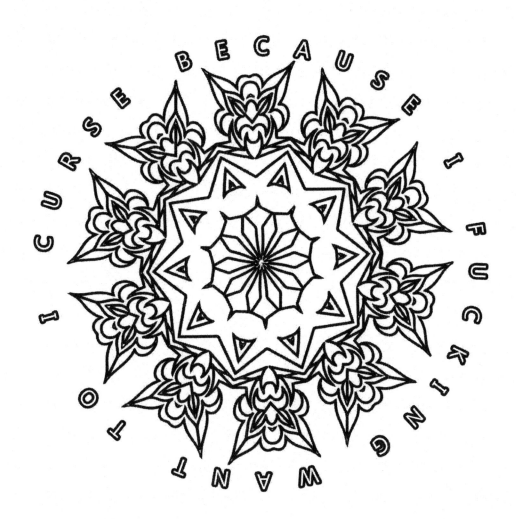

Swear Word Coloring Book
Adults Coloring Book With Some <u>Very Sweary</u> Words

Copyright 2016 'Swear Words Coloring Books'
All Rights Reserved. This book or any part of it may not be used
in any matter whatsoever without the express written permission
of the publisher except for the use of brief quotations in a book review

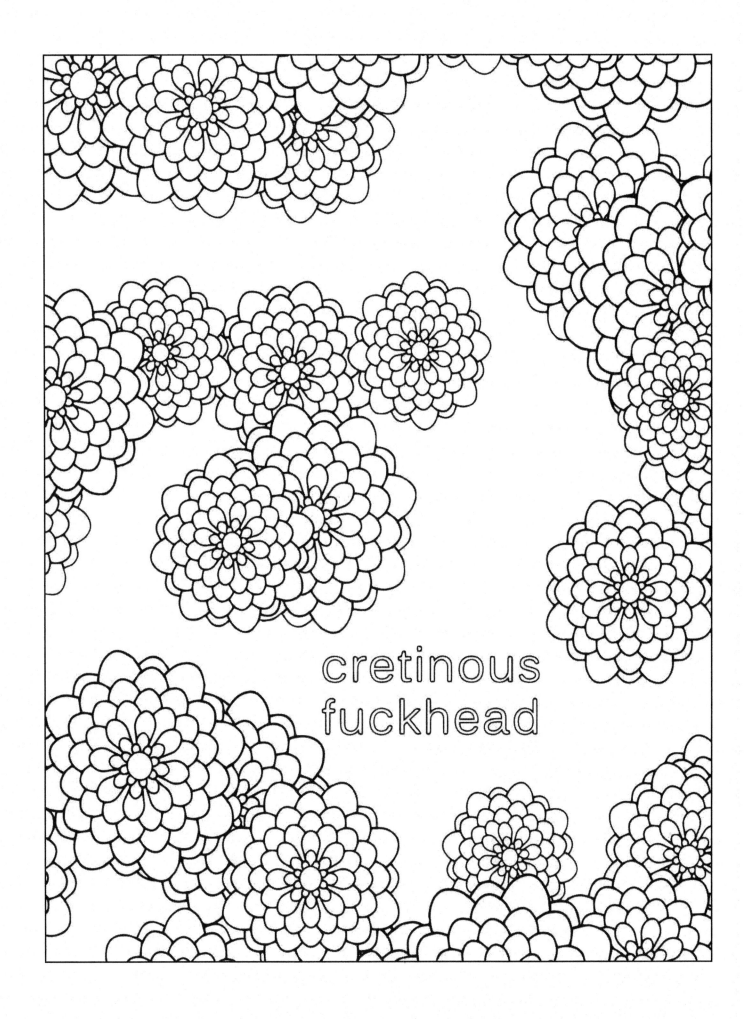

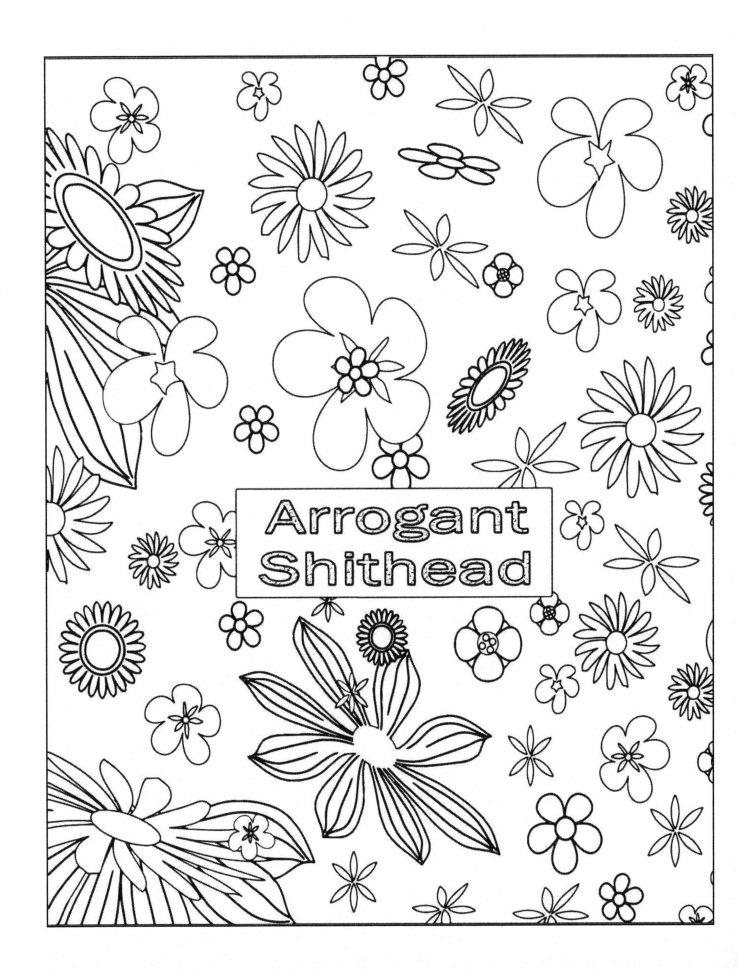

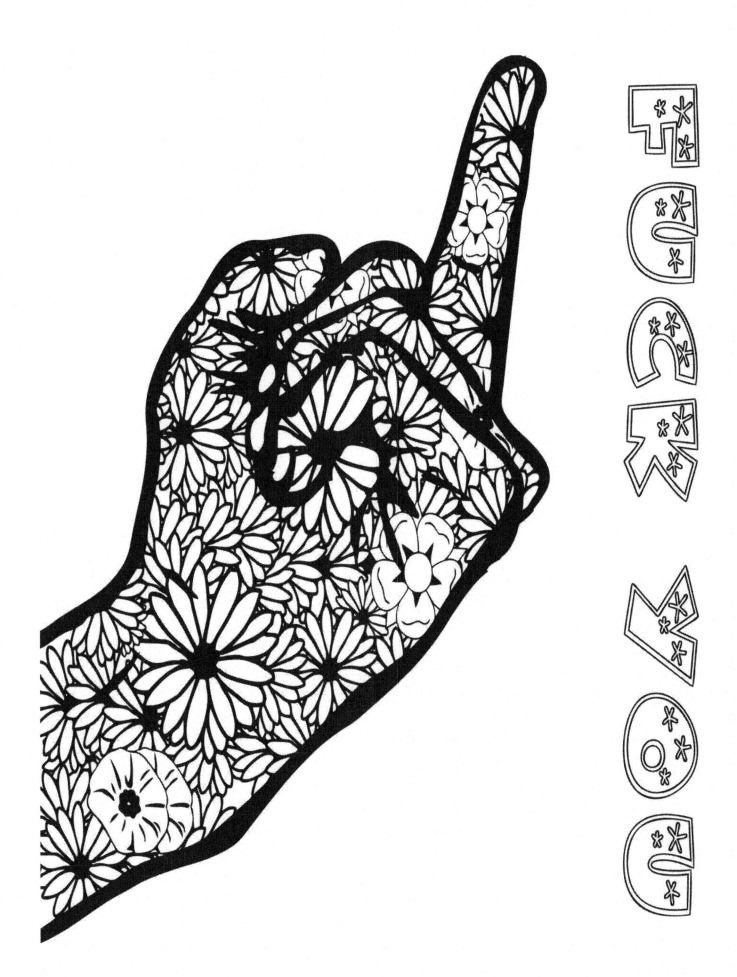

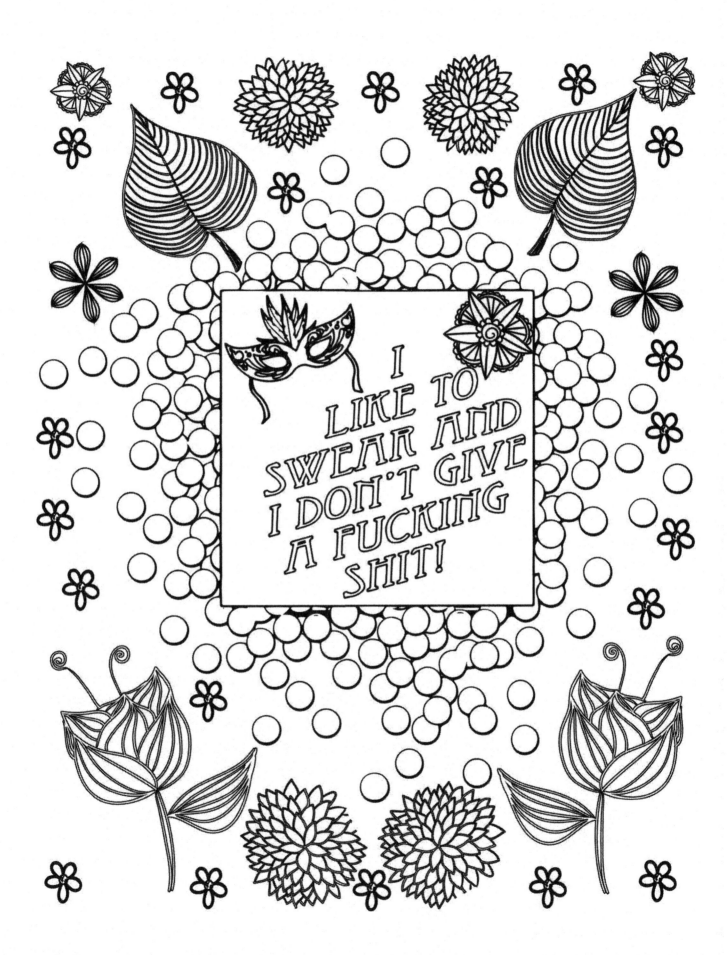

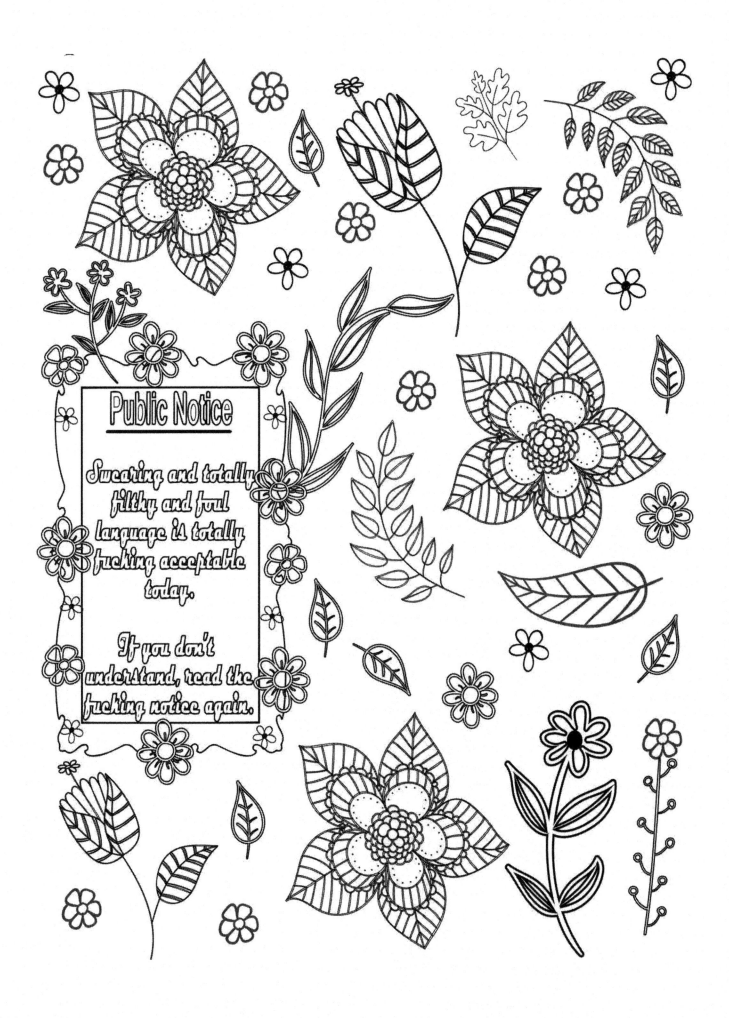

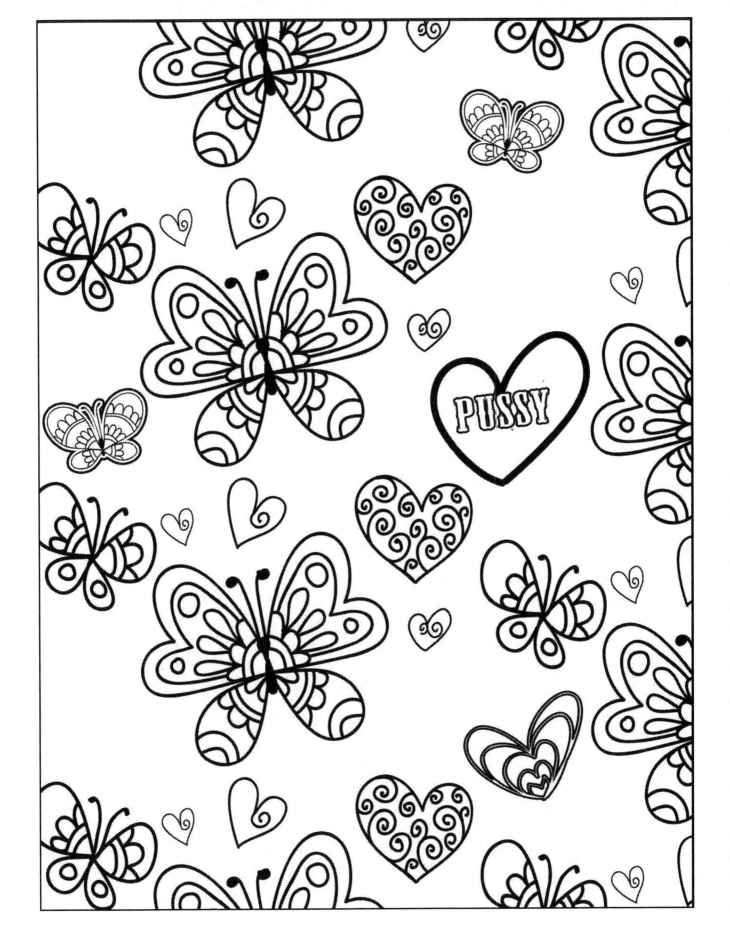

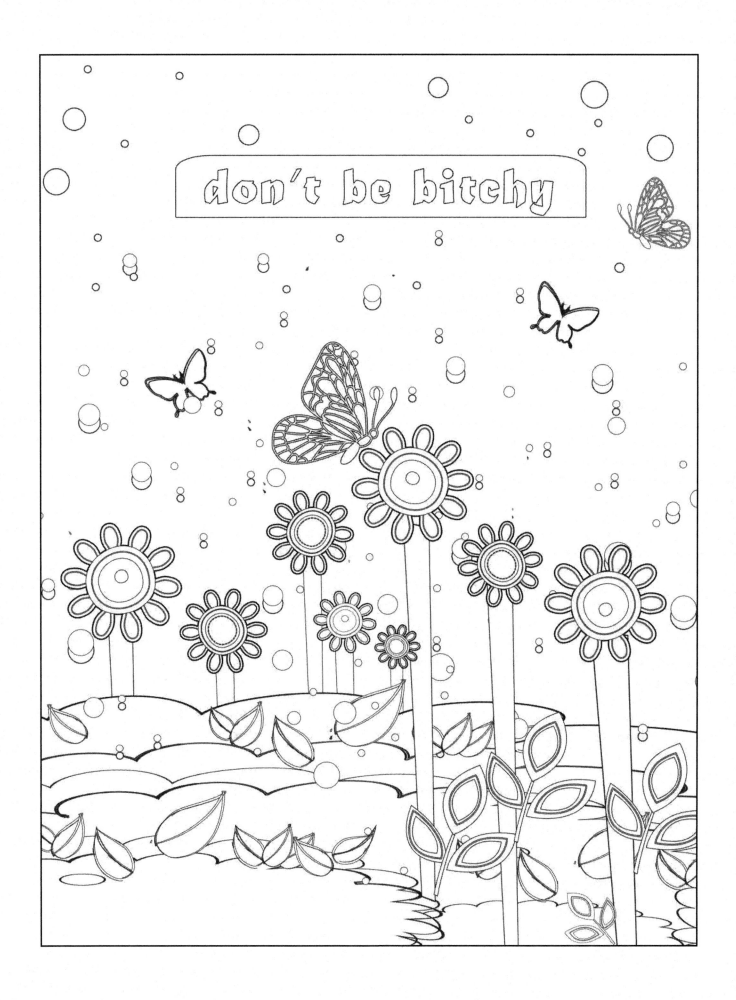

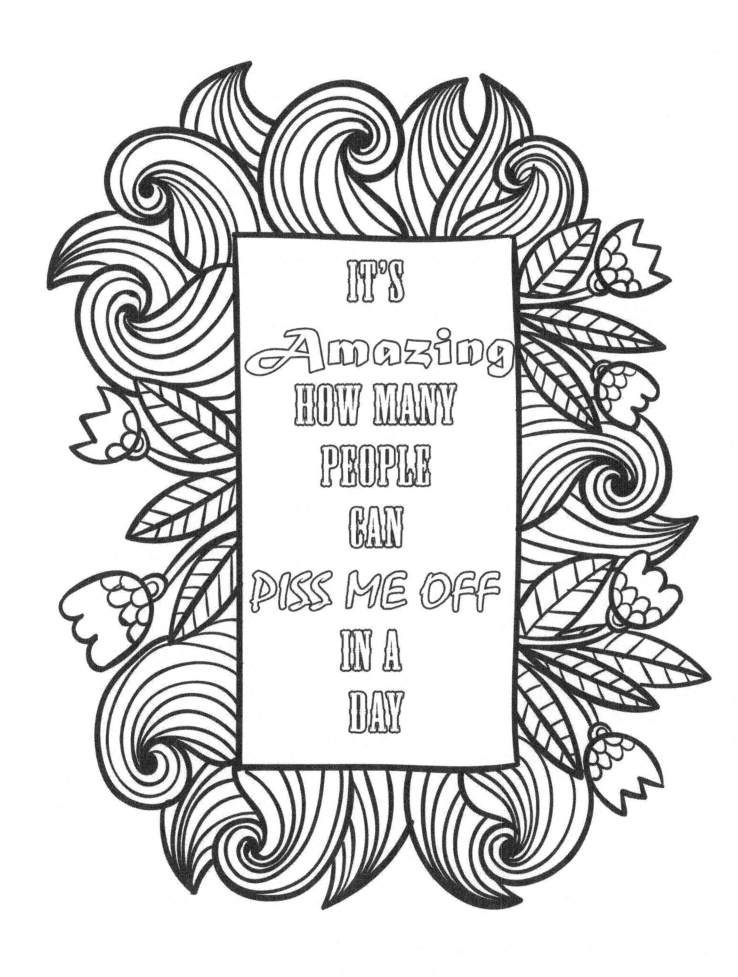

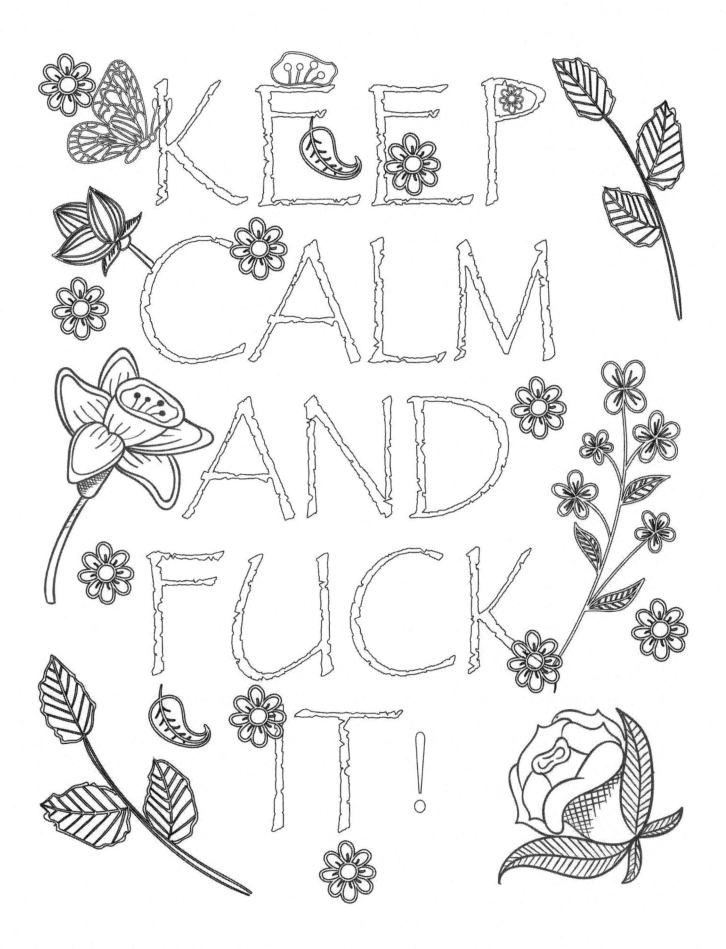

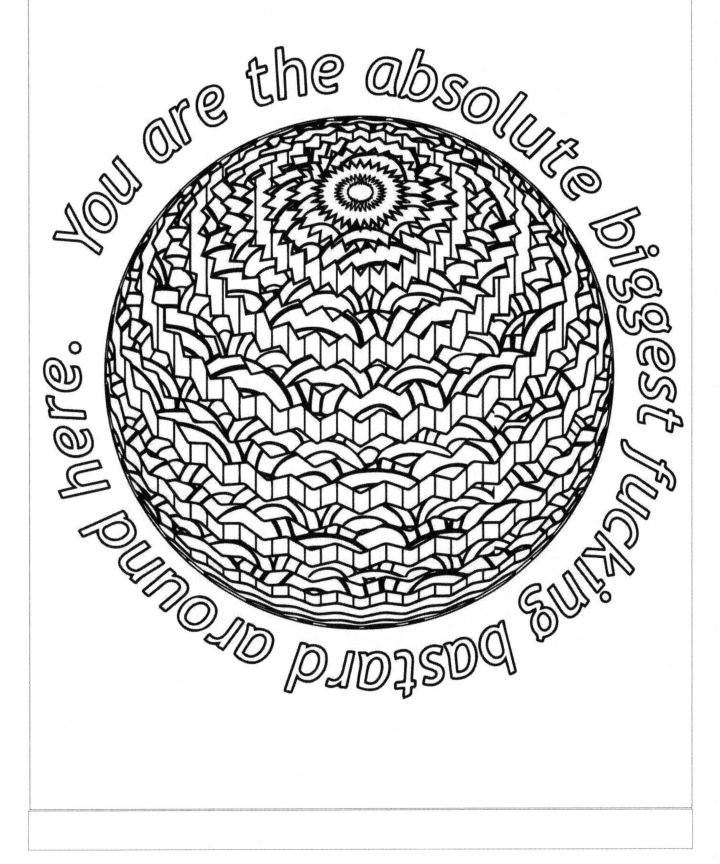

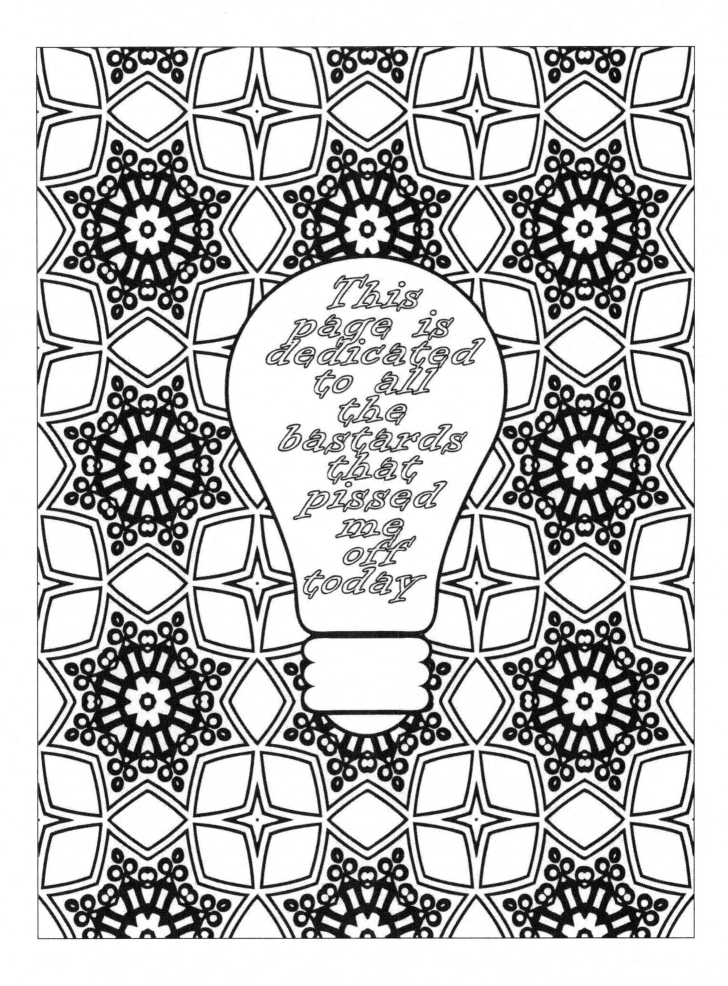

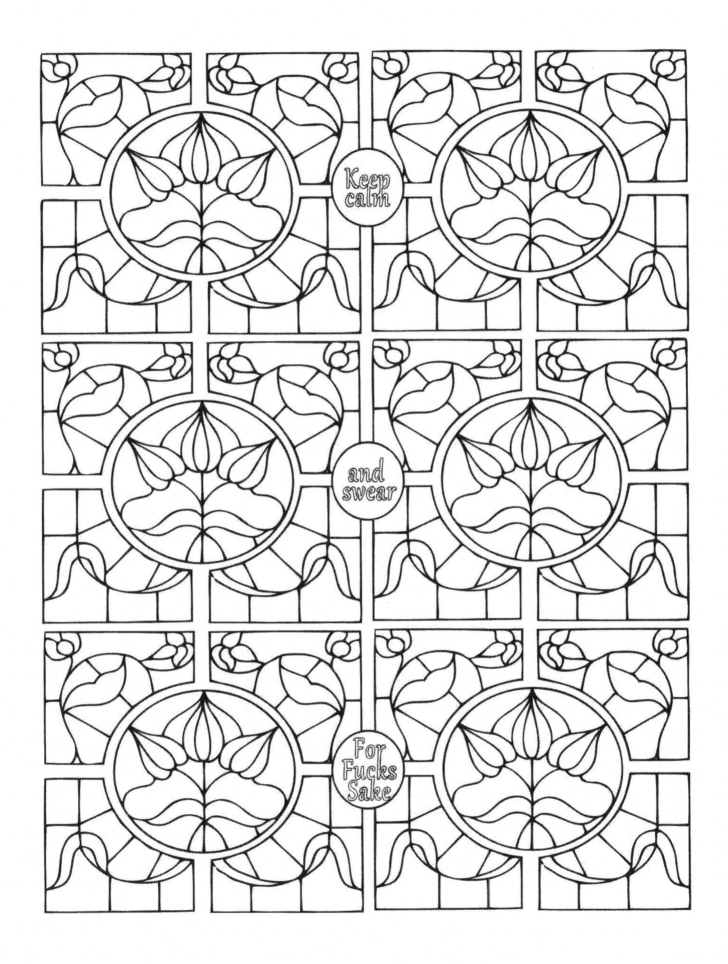

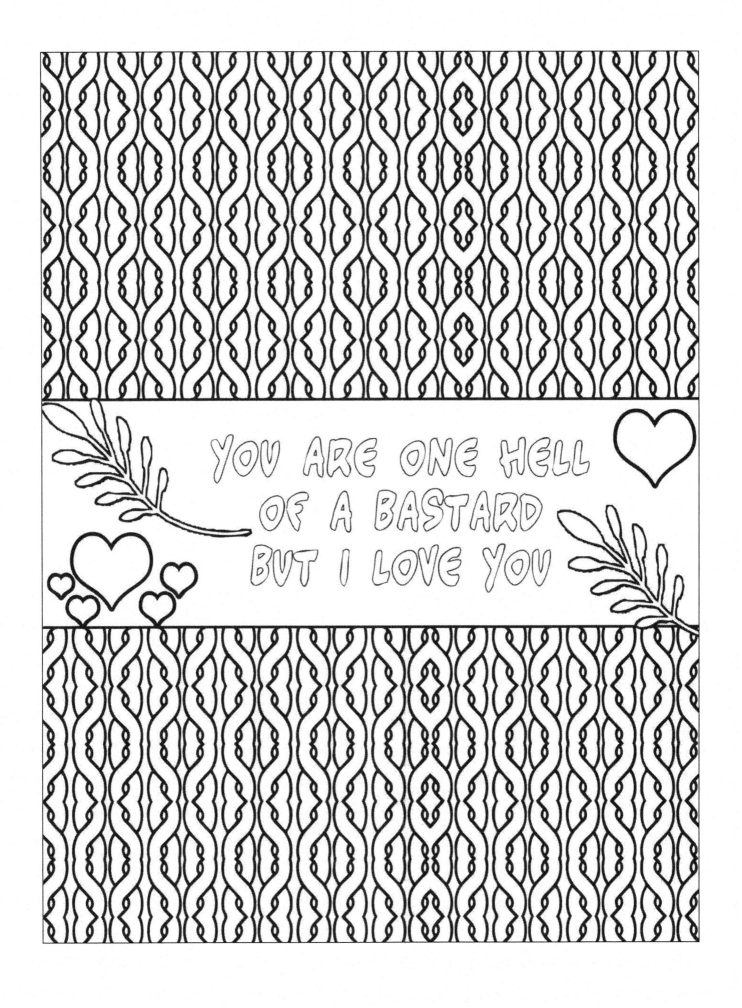

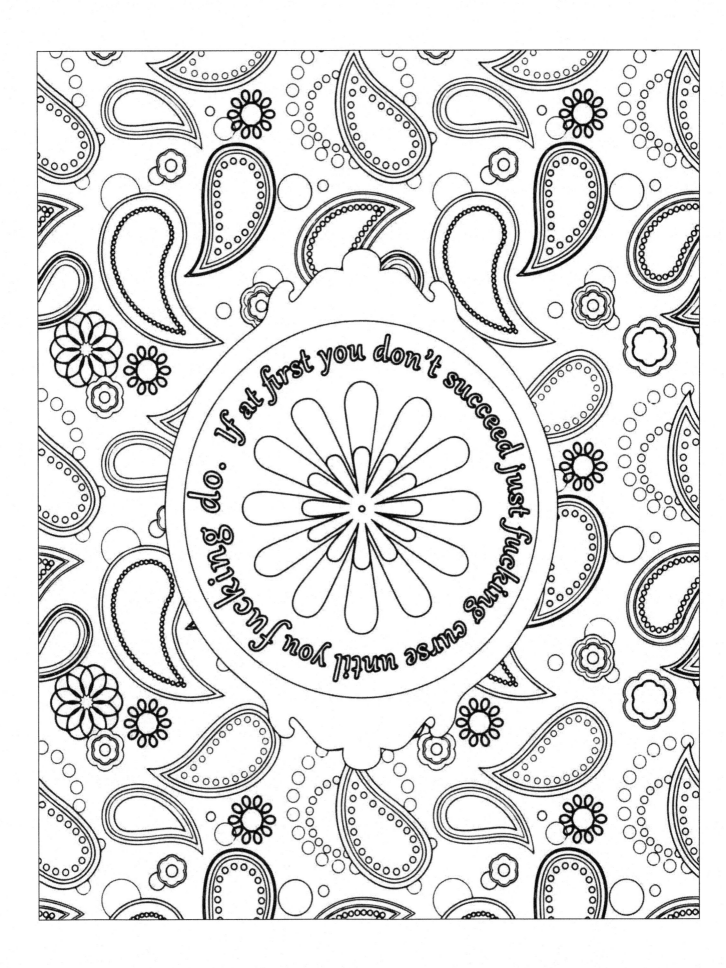

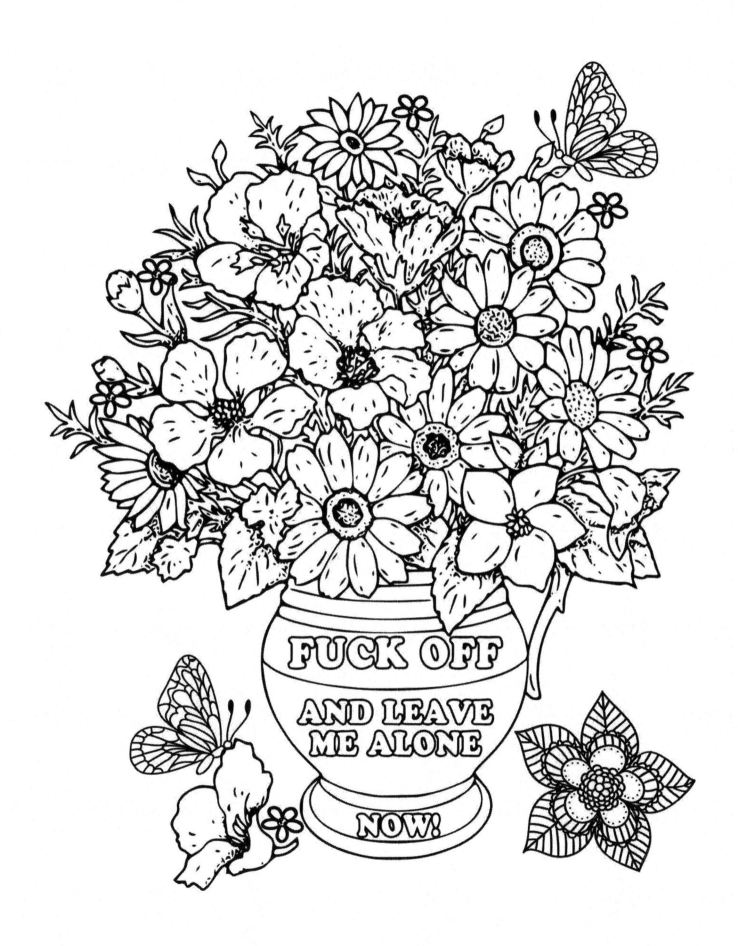

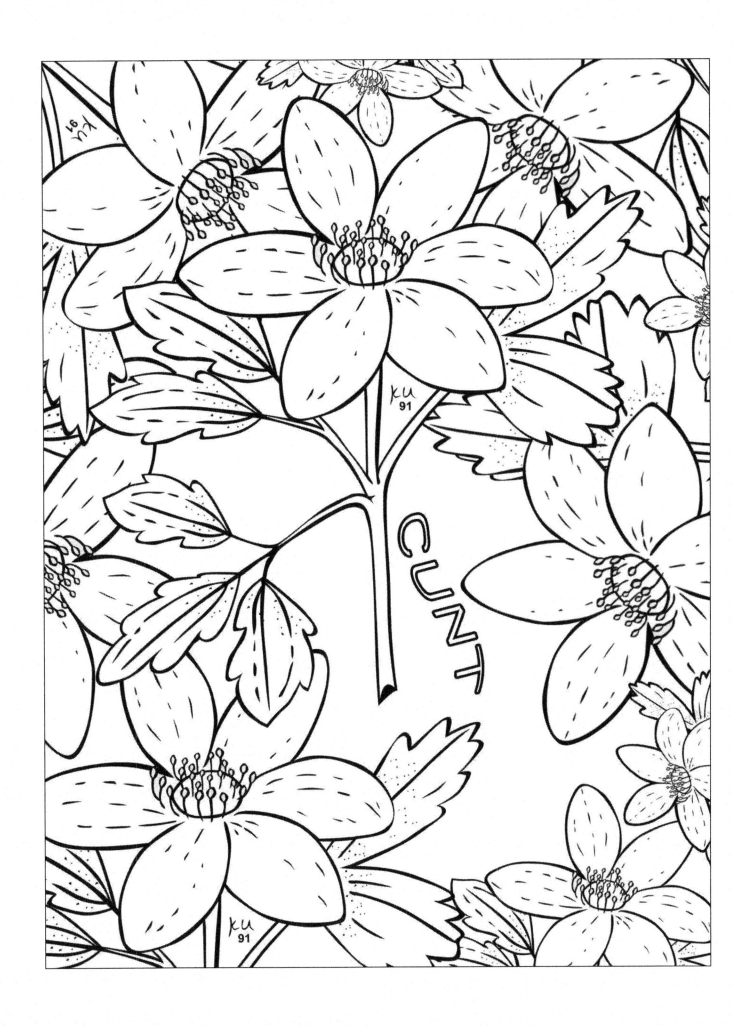

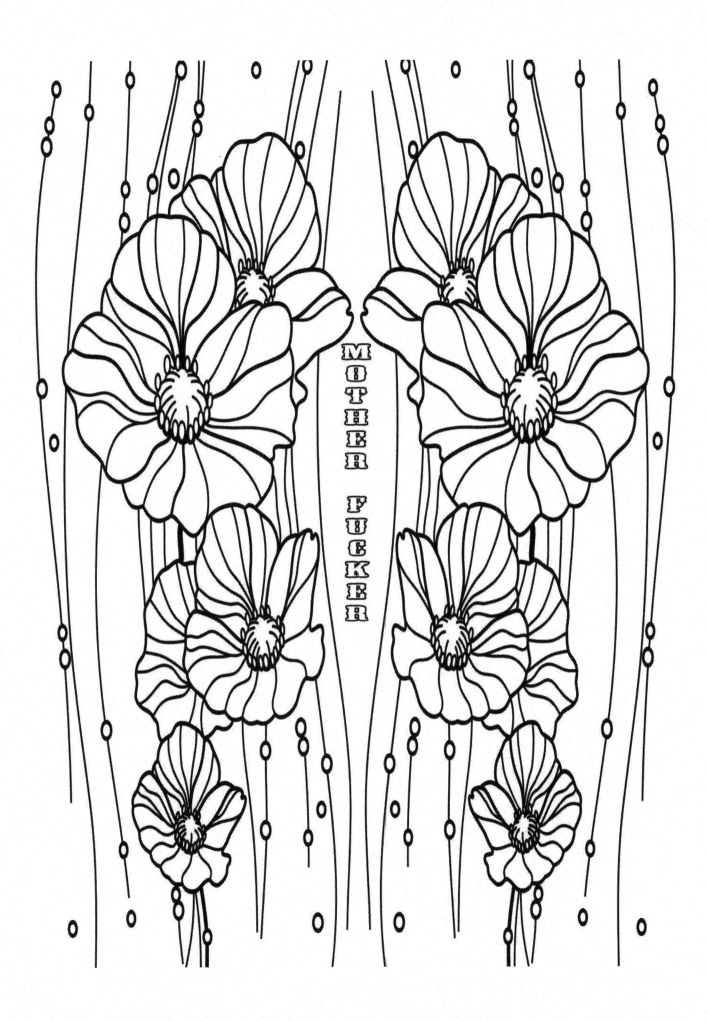

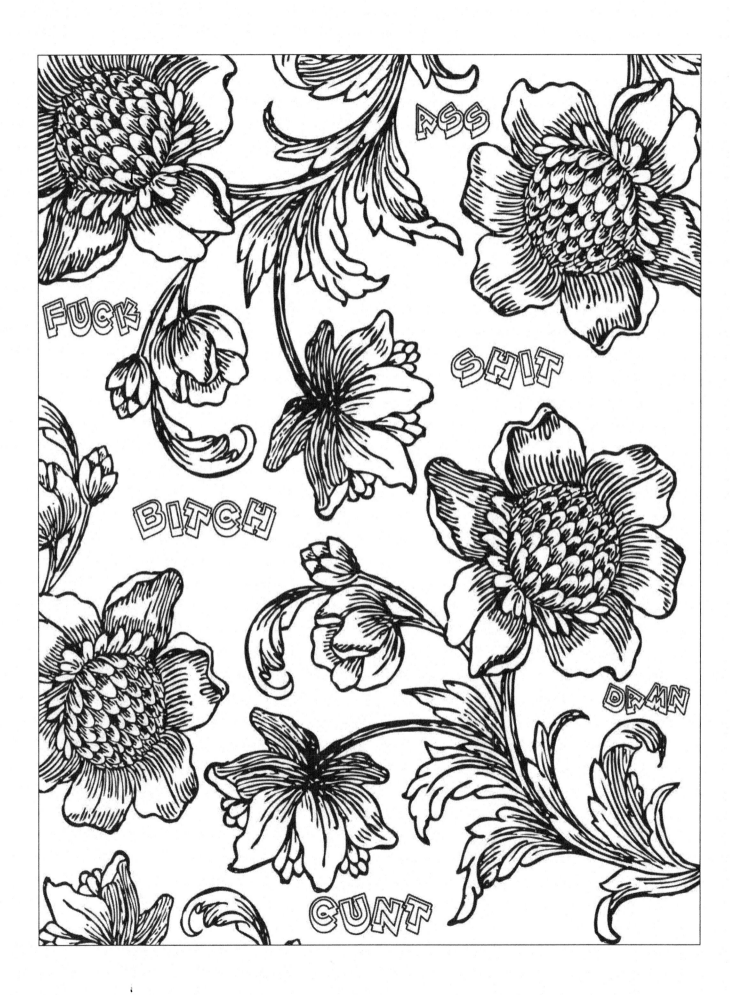

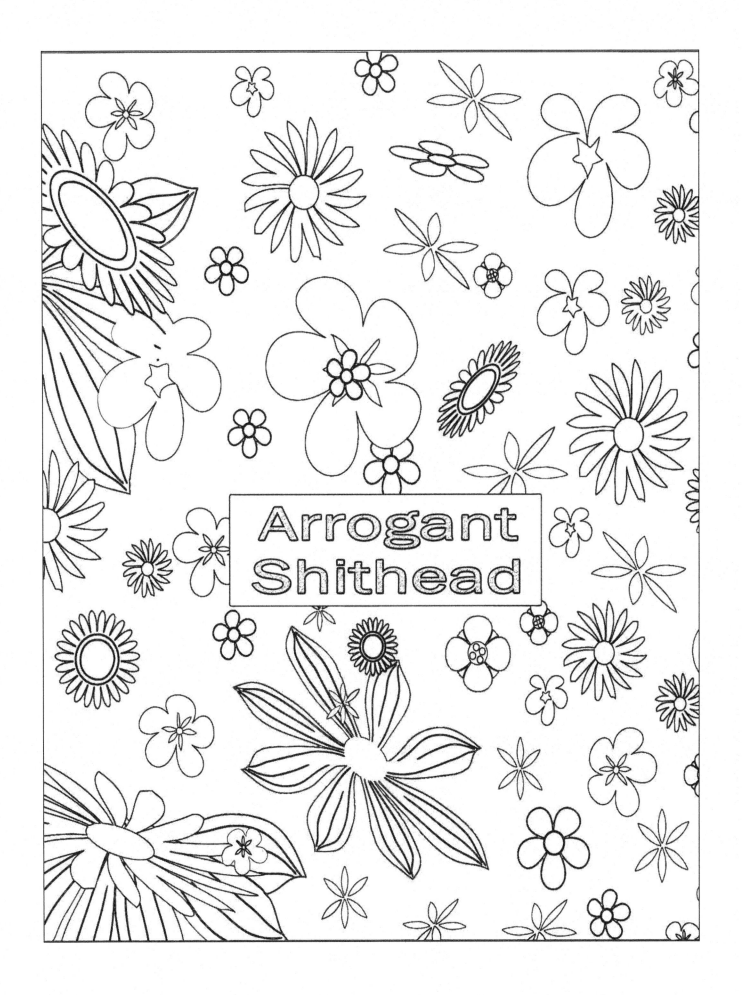

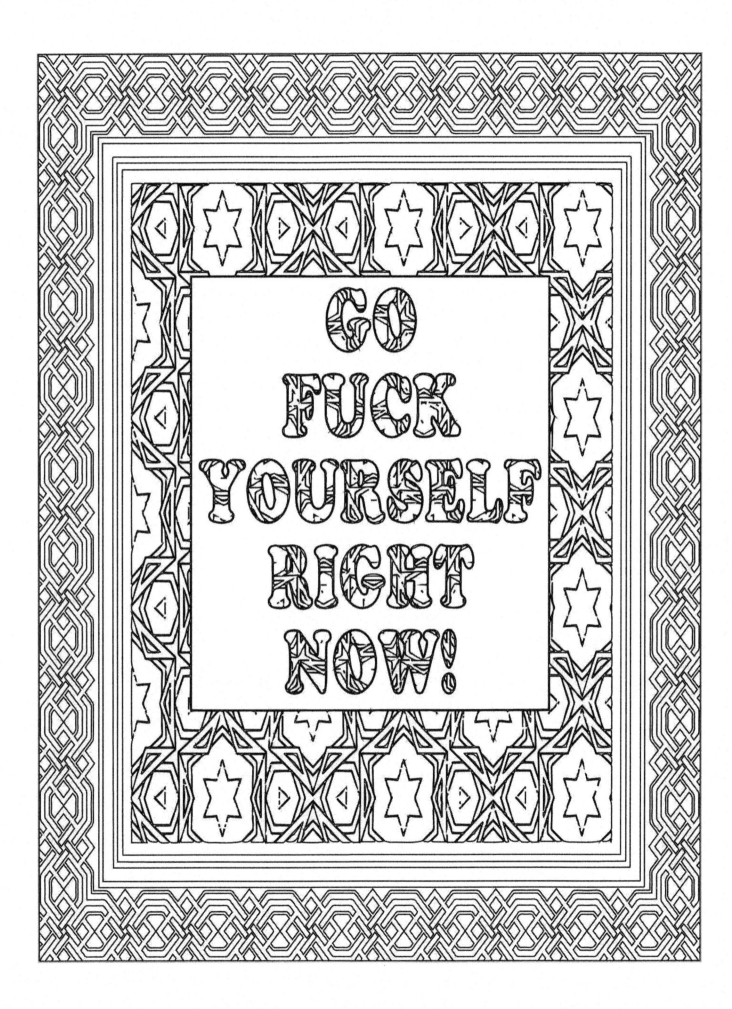

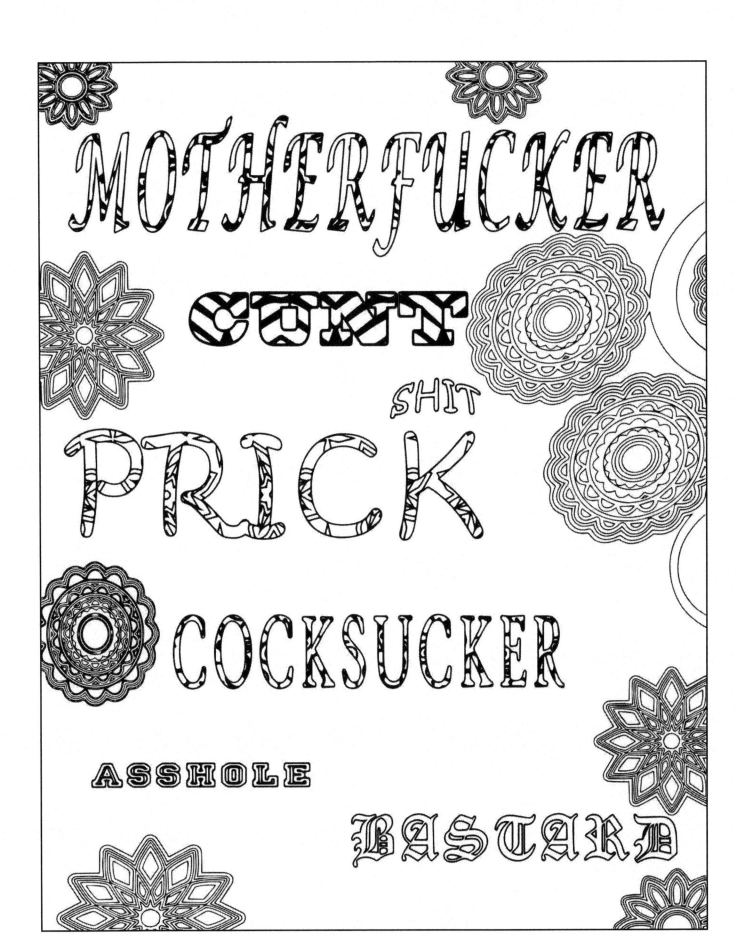

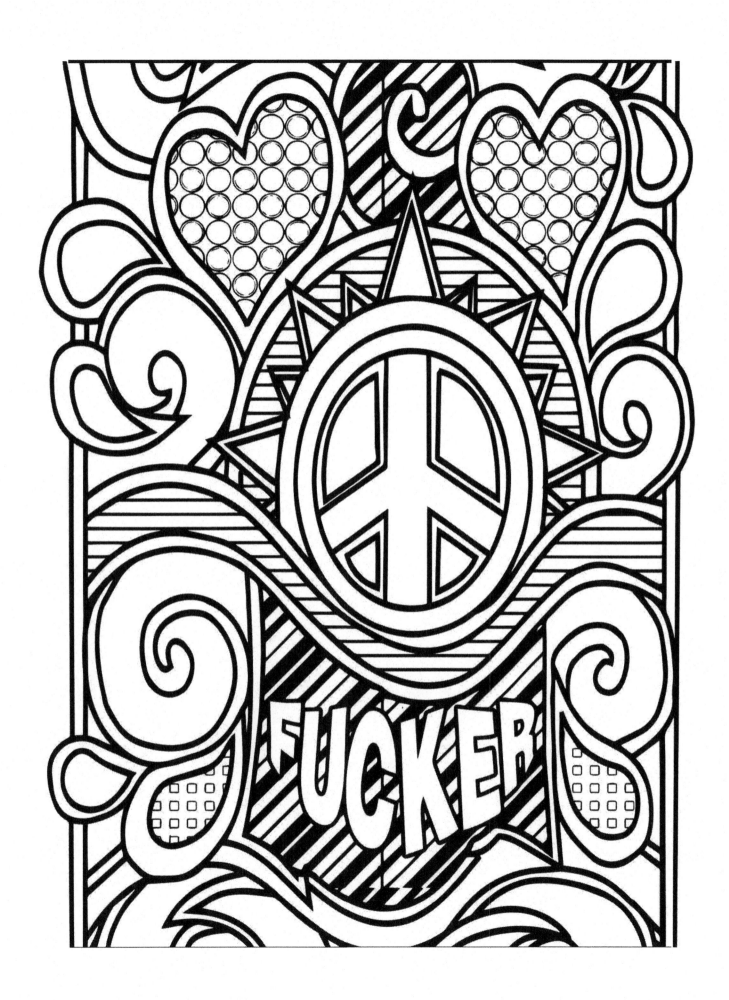

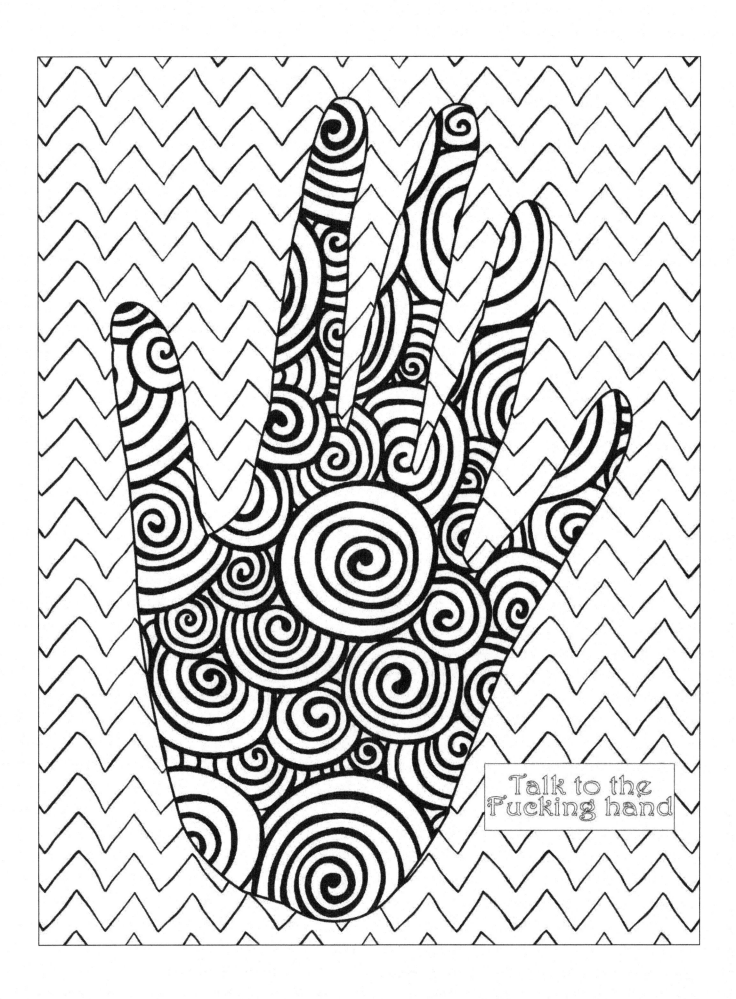

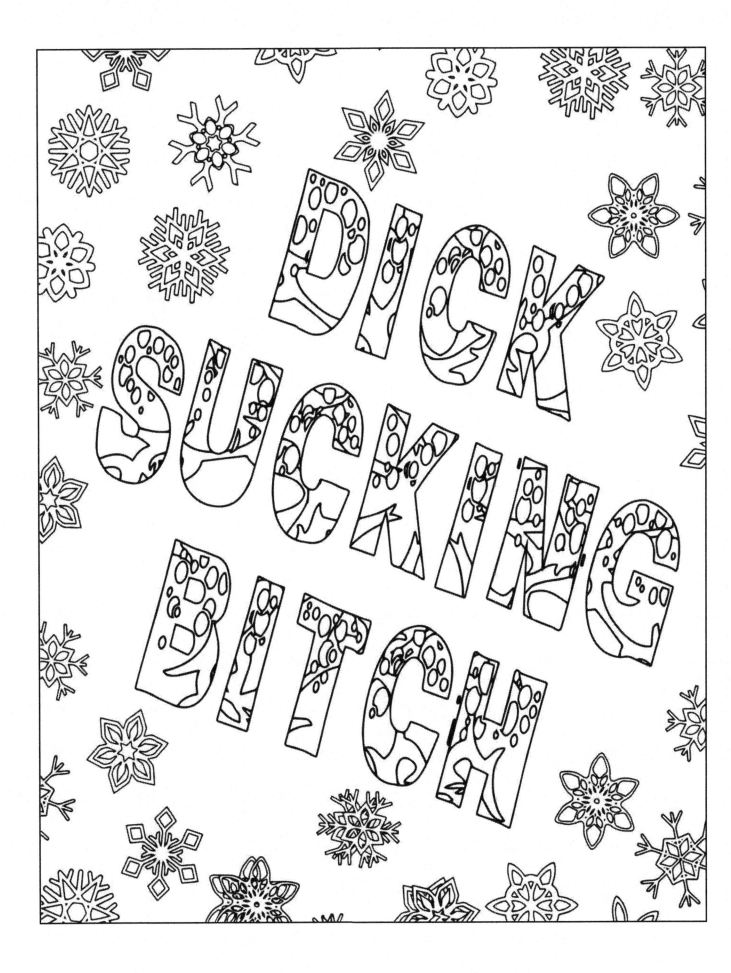

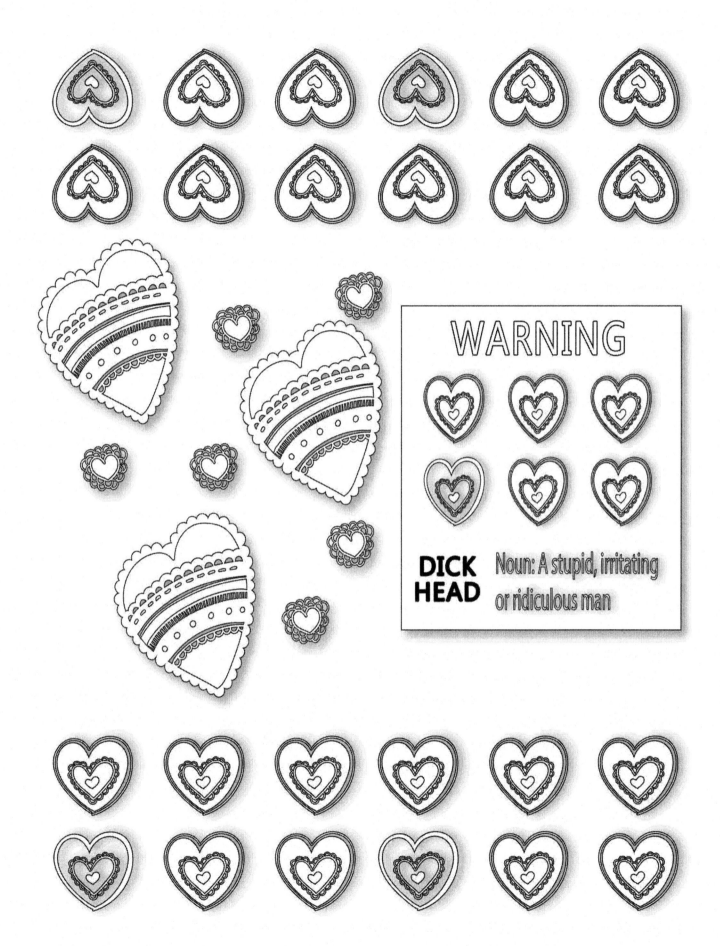

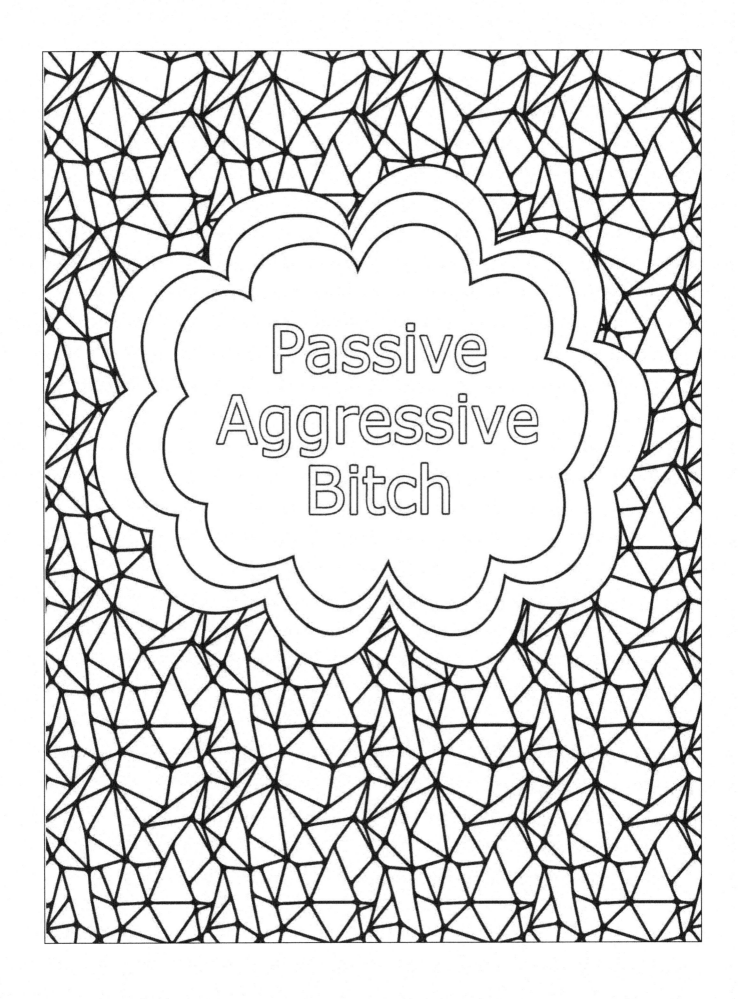

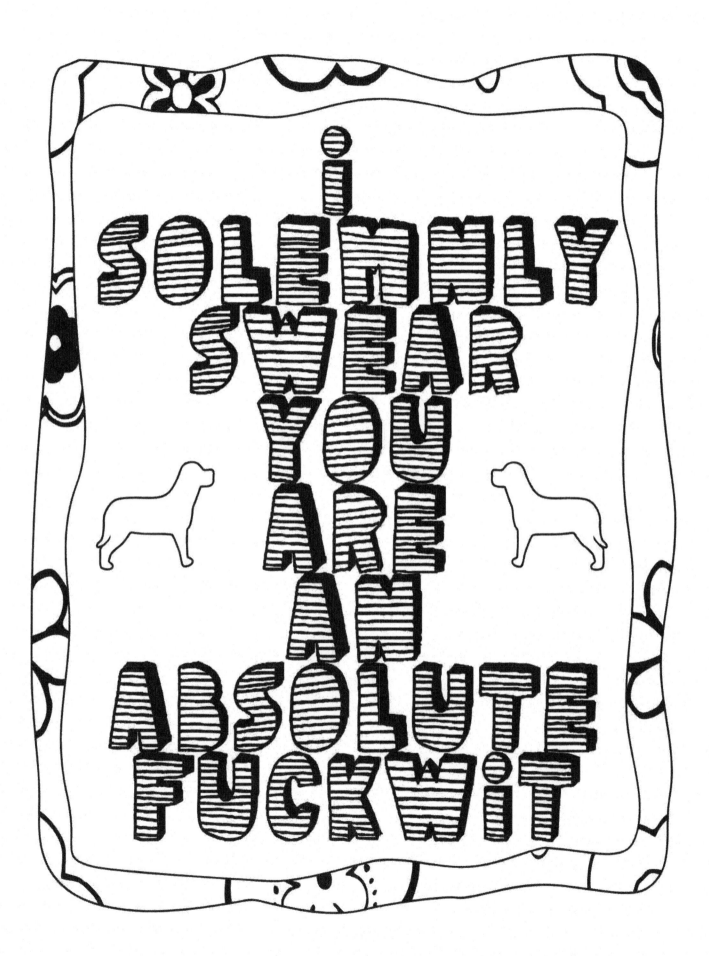

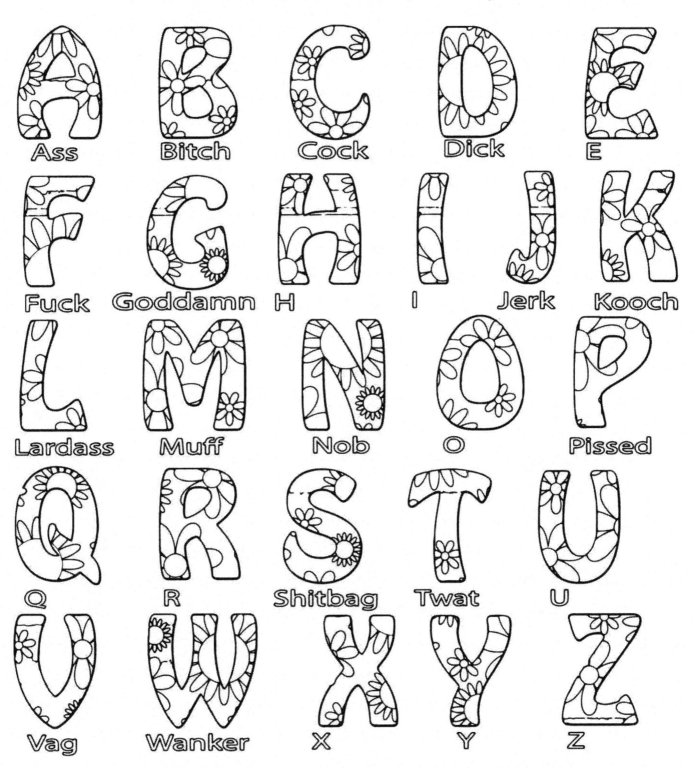

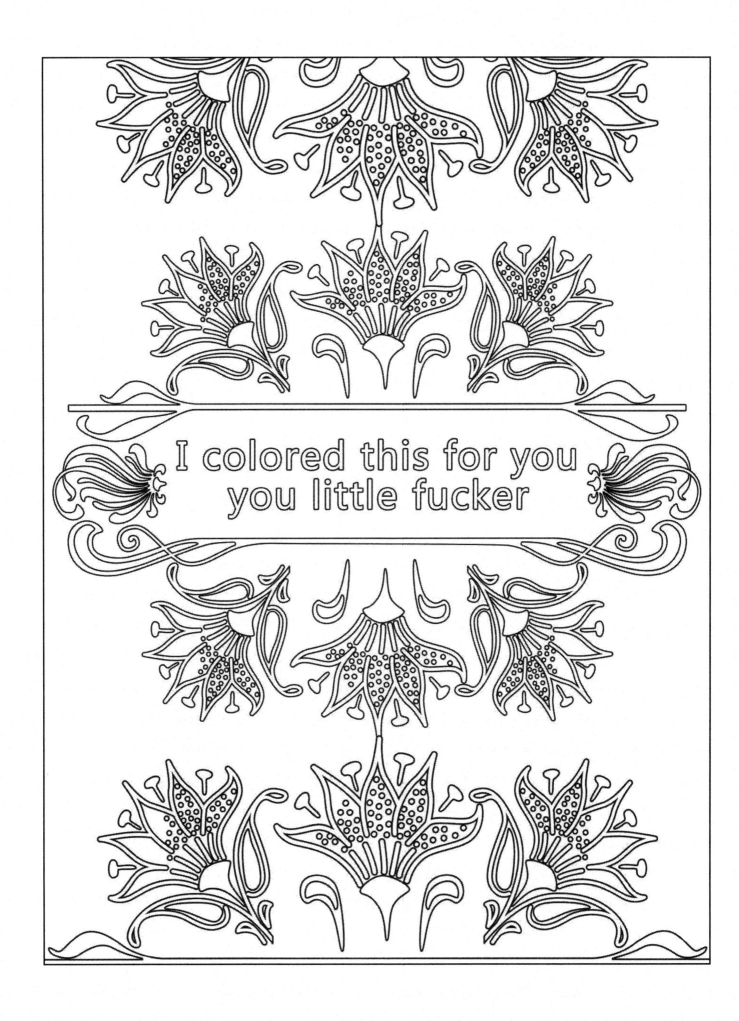

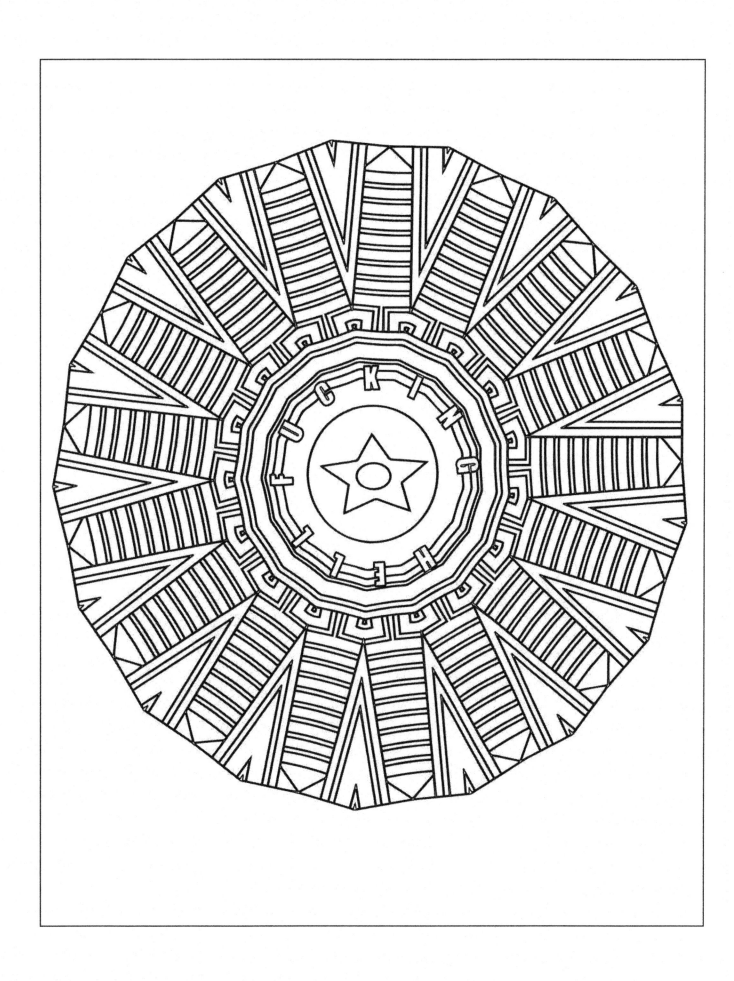

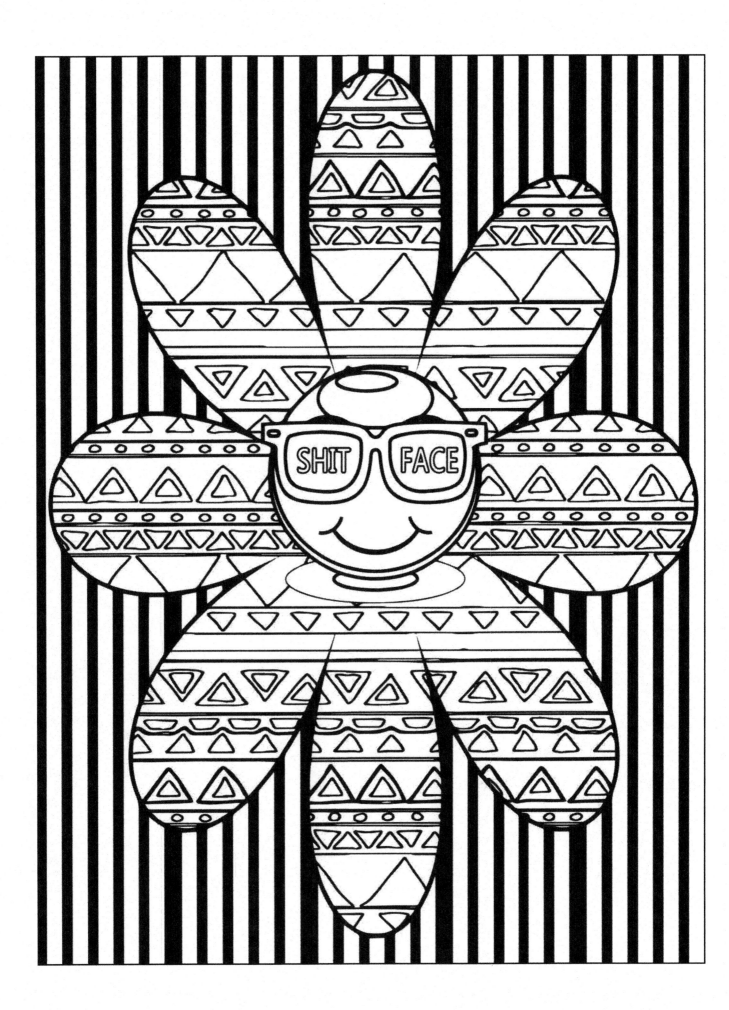

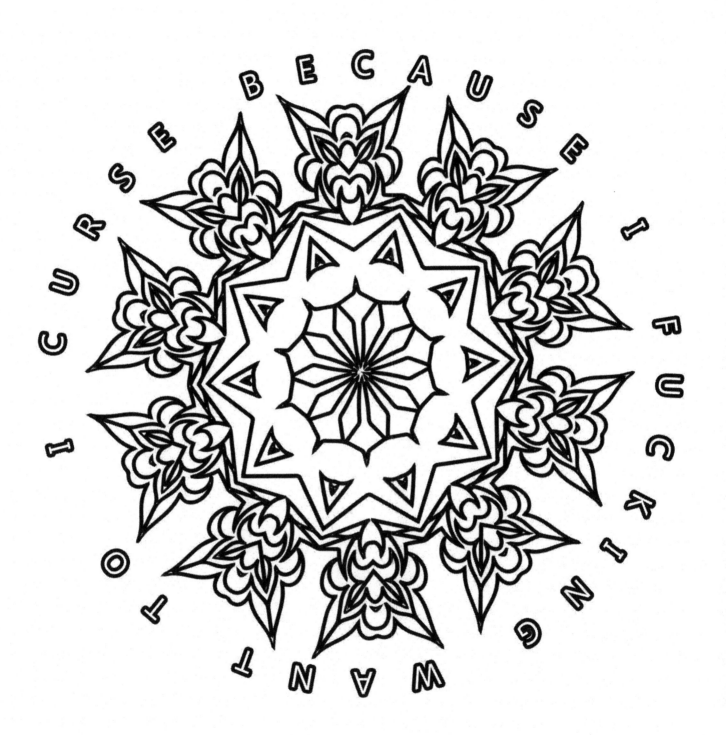

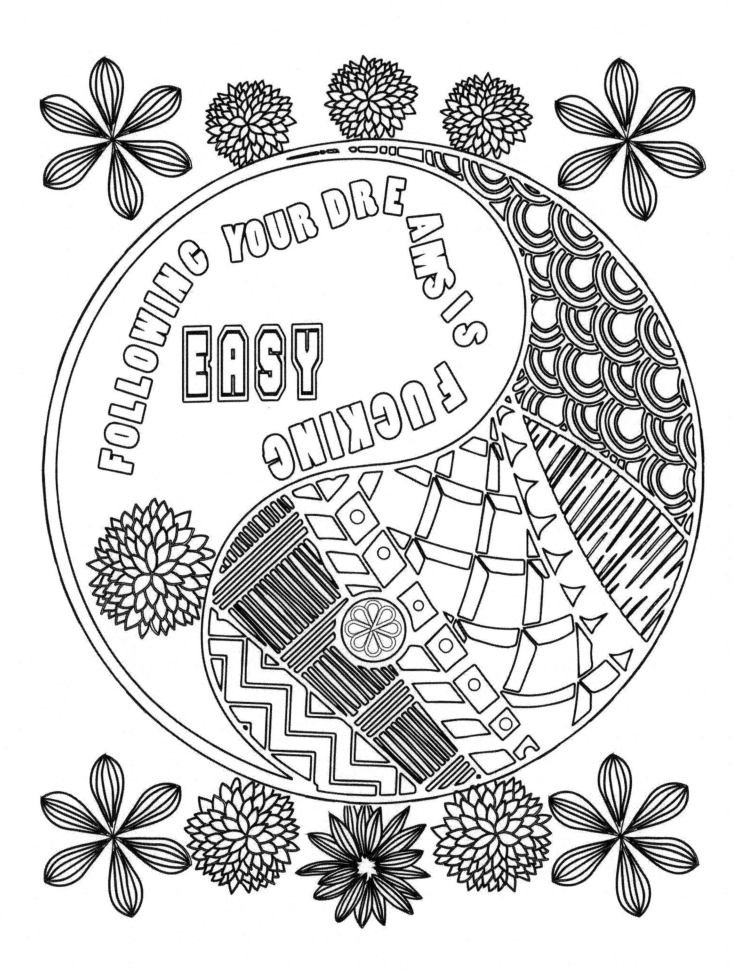

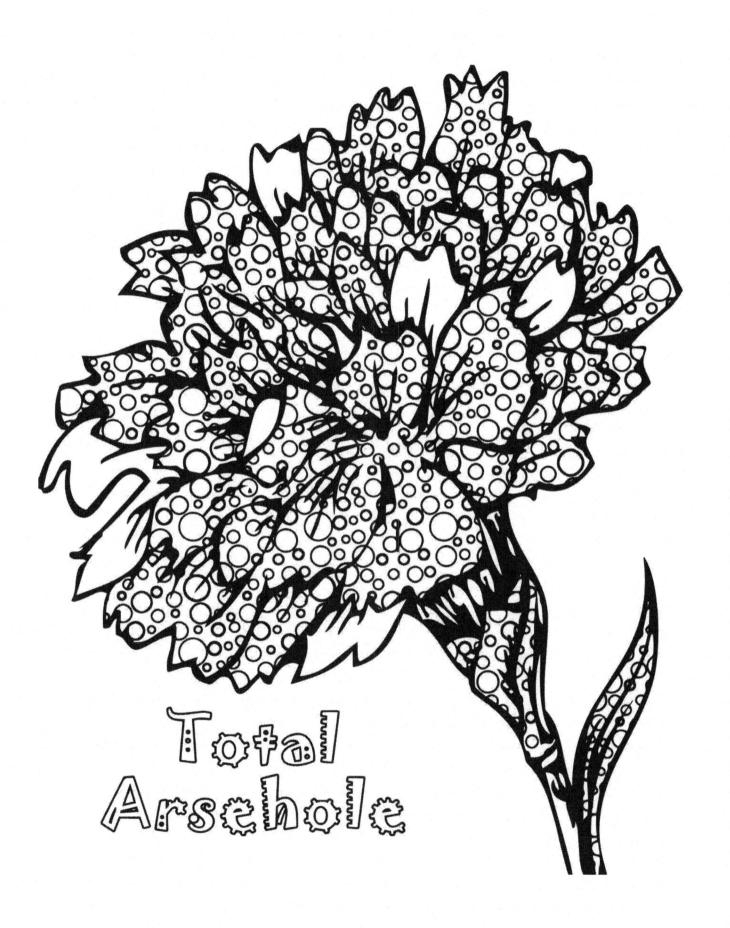

This is an absolutely fucking beautiful picture that I colored just for you

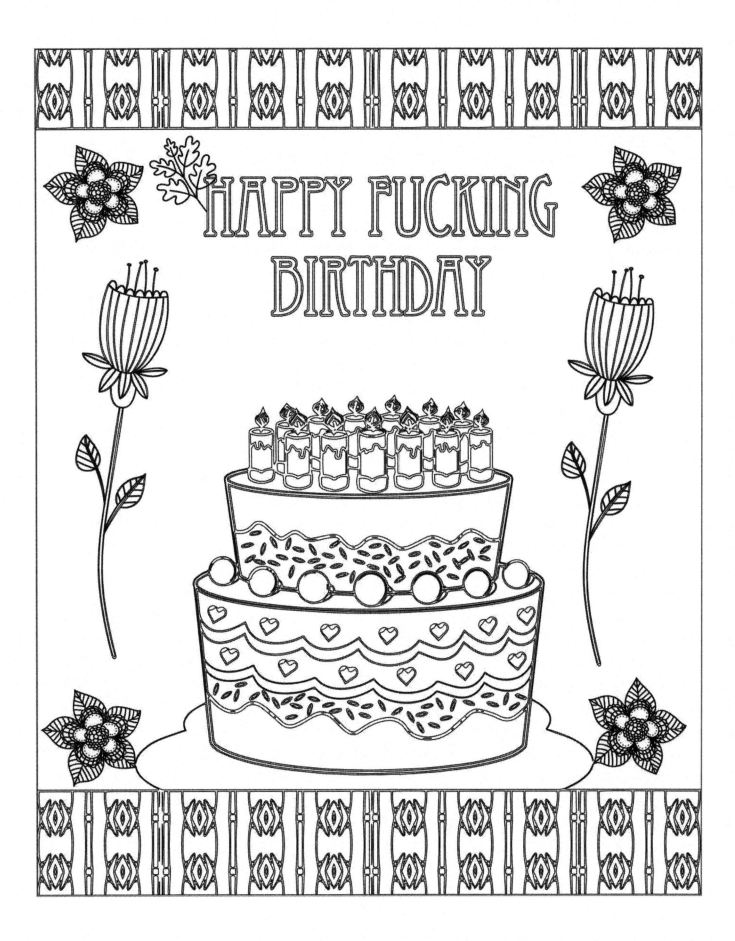

ABOUT SWEAR WORDS COLORING BOOKS

Swear word coloring books are for all those people who need to calm down. Instead of just swearing, we encourage you to color your stresses away instead.

If you need another Swear Words Coloring Book, visit www.swearwordscoloringbooks.com

CPSIA information can be obtained
at www.ICGtesting.com
Printed in the USA
BVOW07s0801301217
504080BV00013B/438/P